AIRBRUSH
ARTIST'S
LIBRARY

RENDERING
TRANSPARENCY

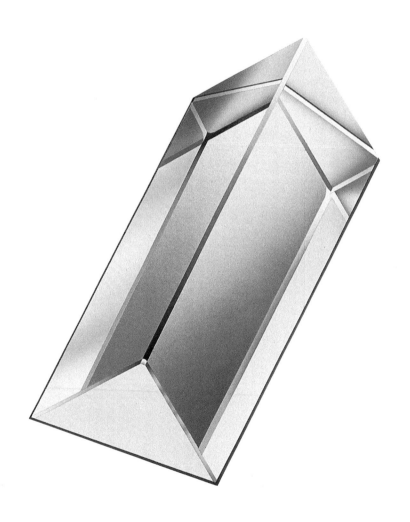

*AIRBRUSH
ARTIST'S
LIBRARY*

*RENDERING
TRANSPARENCY*

JUDY MARTIN

**NORTH
LIGHT
BOOKS**

Cincinnati, Ohio

This book was designed and produced by
QUARTO PUBLISHING PLC
The Old Brewery, 6 Blundell Street
London N7 9BH

SERIES EDITOR JUDY MARTIN
PROJECT EDITOR MARIA PAL
EDITOR RICKI OSTROV
DESIGN GRAHAM DAVIS
PICTURE RESEARCHER JACK BUCHAN
ART DIRECTOR MOIRA CLINCH
EDITORIAL DIRECTOR CAROLYN KING

Typeset by Ampersand Typesetting (Bournemouth) Limited
Manufactured in Hong Kong by Regent
Publishing Services Ltd
Printed by Leefung-Asco Printers Ltd, Hong Kong

A QUARTO BOOK

First Published in the USA by
North Light Books, an imprint of
F & W Publications, Inc
1507 Dana Avenue
Cincinnati, Ohio 45207

ISBN 0-89134-278-8

CONTENTS

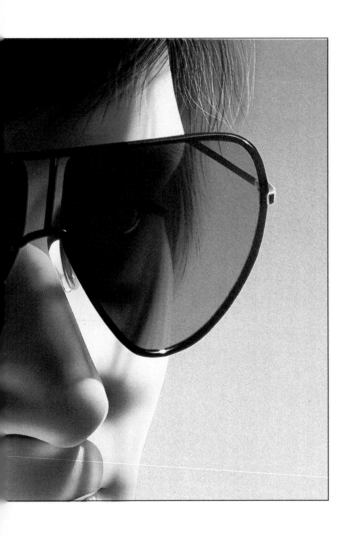

RENDERING TRANSPARENCY AND TRANSLUCENCY

An object or material that is transparent or translucent has the quality of transmitting light through its own substance. When a surface is transparent, anything that lies beyond the surface can be seen through it with relative clarity: translucency implies that a material is not solidly opaque and can be seen through, but the light is partly blocked or filtered, giving a diffused or distorted impression of what lies beyond.

The most commonly used material with this property is glass, and this is formed into flat sheets, or solid and hollow objects, may be colorless or colored, smooth or textured. Synthetic plastic materials made to simulate glass are also seen in a variety of forms. Since these materials are also reflective, the surface

...ualities can be extremely complex. In this book, the visual effects of the materials' reflective properties are kept to a minimum in order to describe as clearly as possible the basic qualities of transparency and translucency.

Glass and plastic are rigid materials, but there are soft, flexible materials that, because of their weight and texture, also transmit light and reveal underlying forms: among these are sheer fabric and paper, also described in the airbrushing projects illustrated in the following pages.

Airbrushing is a particularly suitable medium for describing transparent and veiled effects, as the fineness of the airbrush spray allows the artist to build up an image layer upon layer, introducing subtle definitions of overlapping shapes. The projects in this book demonstrate the techniques by which different effects can be achieved, starting with basic exercises in describing transparent planes and solid forms and moving on through a variety of images representing a range of subject matter suited to airbrush painting. Watercolor is used throughout (colored inks could alternatively be used, but not gouache), as this is a paint medium which is itself transparent, laying a fine veil of color that modifies rather than obliterates colors and tones previously applied. The only exception to this rule is in certain effects of highlighting that require the use of opaque white paint thinly applied to produce a semi-transparent finish that also suggests the element of reflectiveness.

To focus the problem of conveying the effect of transparency, certain objects are treated as self-referential — such as the wine glass (pages 18-21) and the green glass bottle (pages 42-47) — although in a composite image their colors and tones would be affected by their surroundings, with varied shapes and colors seen through and reflected in the surface of the glass. In other examples, however, before any work can begin on the actual qualities of the transparent or translucent surface, the objects seen through this surface have to be described in detail (see the sheer curtain, pages 28-31, and sunglasses, page 38-43). In most contexts, it is impossible to separate the transparent object from related objects and the overall surroundings, and it is the combination of elements that eventually provides the authenticity of the image. The transparent object enhances, rather than disguises, other details within the image. A translucent effect softens but does not completely conceal the underlying detail.

This emphasizes the importance of obtaining good visual reference for the effect that the artist intends to convey. The rendering of a transparent or translucent object cannot depend upon technical tricks, in airbrushing or in any other painting medium, but is achieved through highly accurate observation and reproduction of the various elements of shape, color, tone and texture that contribute to the overall effect. Each of the major step-by-step projects in this book starts with a detailed line drawing describing not only the basic form of the object, but also the intricate patterns of light and shade that are created by the density and texture of the material. This information can be obtained by drawings and sketches made directly from the object, or from photographs. The object should be viewed in the context in which it will appear in the image: the lighting, the view through the material and the colors and tones of the surroundings must all be manipulated to contribute the right elements to the visual impression.

TRANSPARENCY AND TRANSLUCENCY: DEGREES OF TRANSMISSION

When rendering a transparent or translucent surface in airbrushing, the important quality that is to be defined is how much light the plane surface transmits, and how this affects the appreciation of an object or succeeding plane that lies behind the original surface and is viewed through it.

These simple exercises are designed to demonstrate this quality as a basis for rendering varied effects in surfaces that transmit light. There are subsequently other elements that can be brought into play, such as effects of surface reflection in association with transparency, as in a glass object, and details of texture or color underlying a translucent veil.

The first exercise shows simply two square planes, one behind the other, in which the front plane is transparent and barely screens the shape behind. This effect is obtained by tonal contrast and opaque overspraying of the overlapping section. In the second exercise, three translucent planes set up a more complex interaction, in which the overlapping of the shapes creates successively darker tones; oversprayed layers of transparent medium allow the tonal contrasts to build gradually.

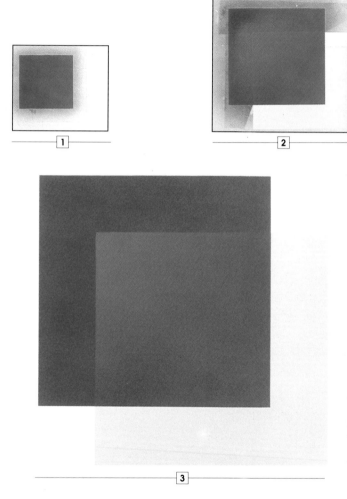

Draw two squares overlapping one another evenly with sides parallel. Apply masking film. Cut the outline of the left-hand square and lift the mask section. Spray a flat tone of blue **1**. Remask the outer edges of the blue square to frame the overlapped area. Spray lightly with opaque white graded from the inner corner **2**. Remove masking from the outer edges of the second square and spray a very pale tone of blue. Remove all masking **3**.

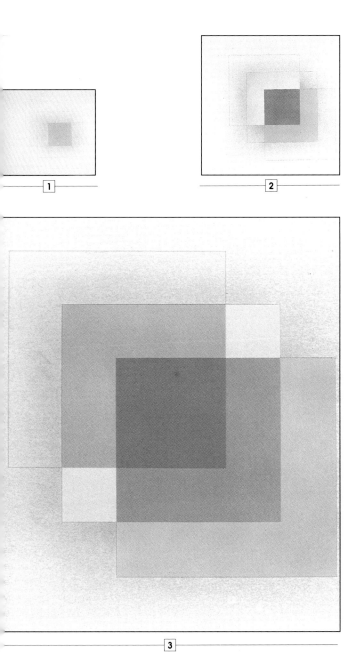

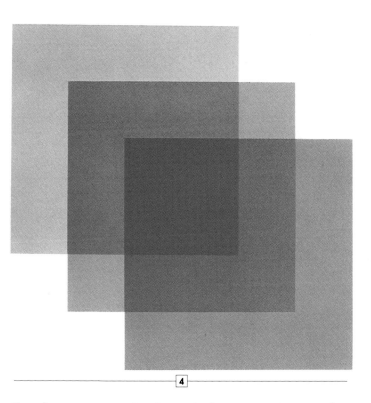

Draw three squares overlapping each other by a regular proportion. Apply masking film. Cut and lift the mask from the central square where all three squares overlap. Spray with blue **1**. Lift the mask in the L-shaped section below the central square and spray with blue. Without replacing any masks, spray the corresponding section above **2**. Continue to remove the mask sections in sequence, allowing the overspray to build up darker tones where the shapes overlap **3**. Complete the image so that the receding planes indicate different tonal values, maintaining the effect of translucency. Remove the remaining masking film **4**.

SOLID OBJECTS: TRANSPARENCY AND TRANSLUCENCY

The exercises in the following pages move one step further from the receding planes, in showing the qualities of transparency and translucency in solid objects. The sphere, cone, cylinder and cube represent the basic combinations of flat and curved planes that the airbrush artist can use as models for specific objects and more complex forms. Each form is presented in two versions, which allows a direct comparison between the transparent and translucent solids and the technique used to achieve each effect.

Broadly speaking, if the object is transparent, the receding planes and far edges can be seen through the nearer faces. In a translucent form, the full structure of the object is less well defined; the thickness of the material tends to screen some of the light that delineates contours. The most difficult shape to deal with in this abstract way is the sphere, which has no edges and is exactly the same form when seen from any angle.

These exercises provide a basic analysis of these qualities in solid form. In the projects that follow, they are put in the context of the effects of color, tone and texture observed in real objects and materials.

TRANSPARENT SPHERE

Draw a sphere and mask out the background. Spray very lightly with graded tone in a circular motion passing through the top edge and sides and below the center. Spray also a fine area across the lower edge, as shown **1**. Gradually build up the tonal density by overlaying thin layers of color, maintaining the highlight areas above the center of the sphere and just above the lower edge **2**. Keep a subtle gradation of tone that emphasizes the roundness of the form. When complete, remove background masking **3**.

TRANSLUCENT SPHERE

Draw a sphere and mask the background area as in the previous example. Spray a fine arc of color around the base of the sphere slightly above the lower edge **1** to establish the main shadow area. Starting at the top of the sphere, outside the masked edge, start to spray in a circular motion, passing around the top of the sphere and down the right-hand side, across the lower arc previously sprayed and up the left-hand side as shown **2**. When complete, remove the masking **3**.

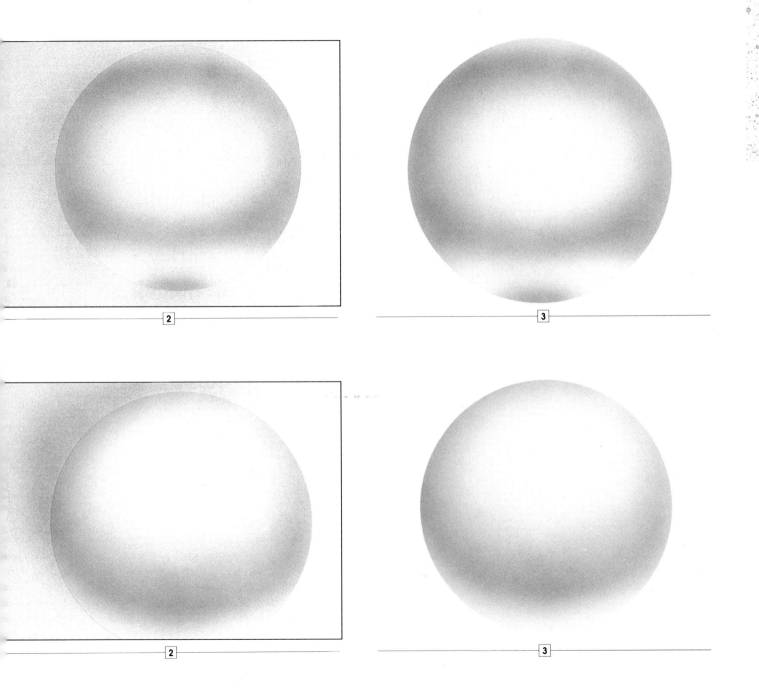

2

3

2

3

SOLID OBJECTS

**TRANSPARENT
CONE**

1

2

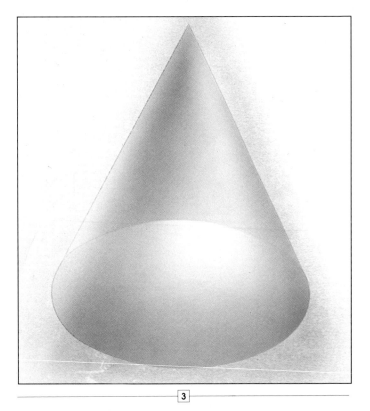

3

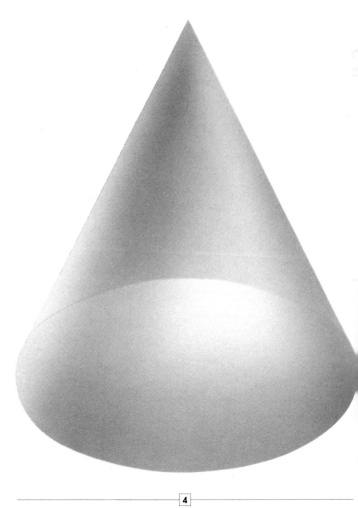

4

Draw the cone in outline and apply masking film to the artboard. Remove the mask from the elliptical base of the cone. Spray a graded tone lightening toward the back of the base plane **1**. When the color is dry, replace the mask section and lift the masking film covering the top section of the cone. Spray a flaring band of graded tone from the tip of the cone falling just left of center **2**. Remove the ellipse mask again and overspray the band of color, working to the front edge of the cone base. Spray the right-hand edge also **3**. Remove the background masking **4**.

TRANSLUCENT CONE

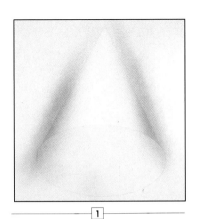

1

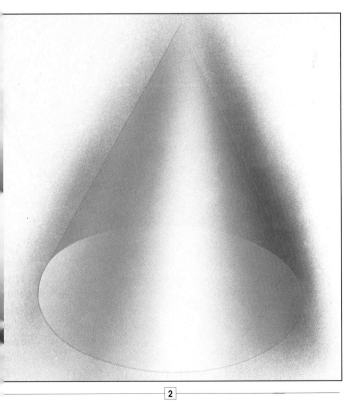

3

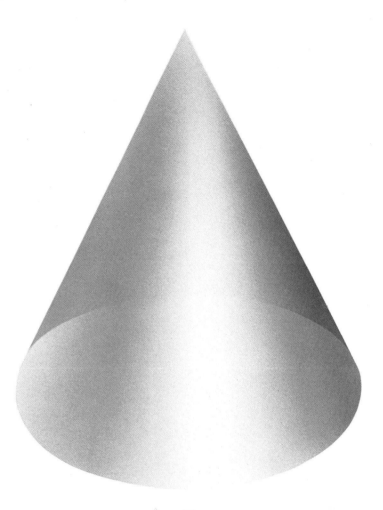

2

Draw the shape of the cone in outline, as in the previous exercise. Apply masking film to the full image area. Cut the mask along all the lines and lift the top section of the cone down to the back curve of the base. Spray down each side of the shape **1**. Build up the tonal density at the back edges of the cone base, then remove the elliptical section of the mask. Spray flaring bands of color from the top of the cone to the front edge of the base, leaving a central band of highlighting **2**. When complete, remove the remaining masking film from the background **3**.

SOLID OBJECTS

**TRANSPARENT
CYLINDER**

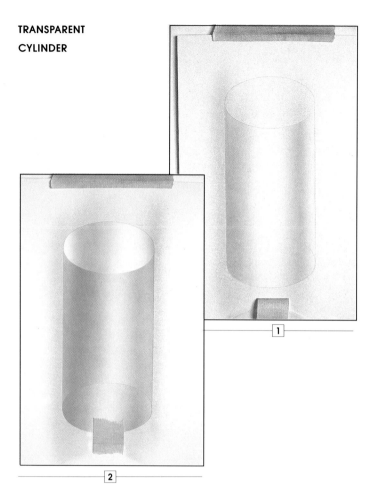

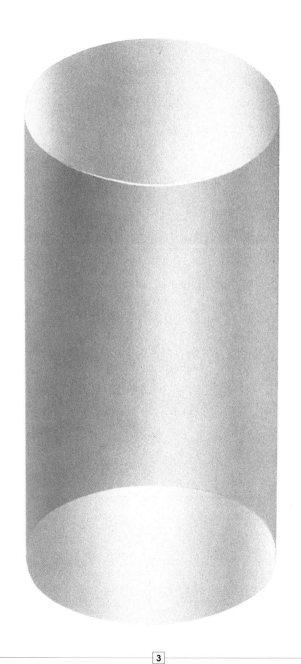

Draw the outline shape of the cylinder and cover with masking film. Cut and lift the section of mask covering the vertical face of the cylinder and hinge back the mask section covering the lower ellipse. Spray bands of graded tone down each side of the cylinder **1**. When the color is dry, replace the ellipse mask at the base and respray the vertical bands of tone to build up the density. Allow to dry. Remove the upper ellipse mask and spray graded tone inside the left-hand section and at the right-hand edge as shown **2**. Remove all the masking film **3**.

TRANSLUCENT
CYLINDER

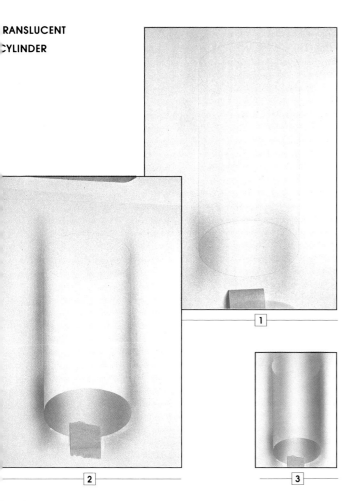

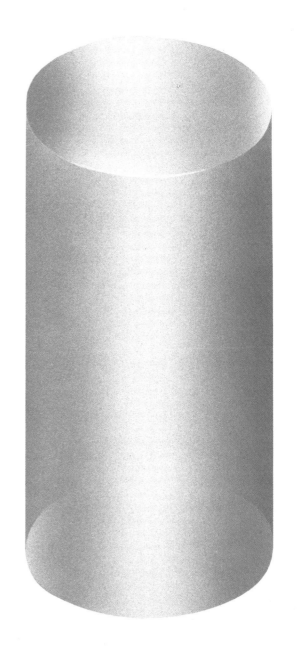

Draw and mask the cylinder as in the previous exercise. Cut and hinge back the ellipse mask on the base of the cylinder. Spray bands of graded tone down each side of the ellipse **1**. When the color is dry, replace the ellipse mask and remove masking from the curved vertical face of the cylinder. Spray bands of graded tone down each side **2**. Build up the density of tone to establish the edges of the planes. When dry, unmask the upper ellipse and spray graded tone vertically, slightly offset against the tonal gradation of the curved face **3**. Remove all masking film **4**.

TRANSPARENT
CUBE

1

2

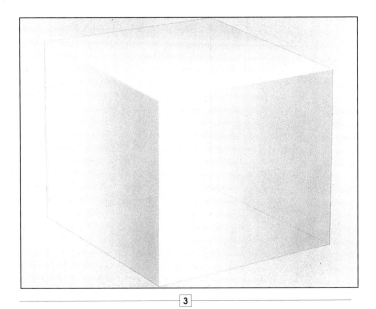

3

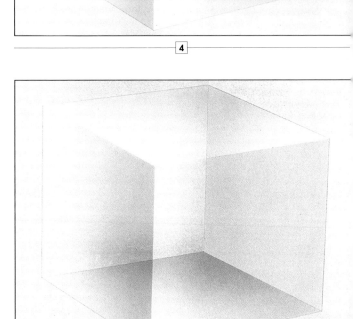

4

5

Make an outline drawing of the cube showing all six faces; cover with masking film. Remove the mask from the left-hand plane and spray graded tone **1**. Repeat in the right-hand foreground plane **2** and the horizontal top plane **3**. Mask off the ground plane; spray with graded tone darkest at the back corner **4**. Mask the vertical line joining the far corners of the cube and spray graded tone against the masked edge **5**. Mask the left-hand background plane and spray graded tone **6**. Remove all masking **7**.

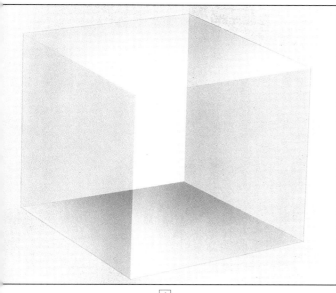

6

TRANSLUCENT
CUBE

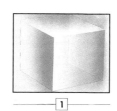

1

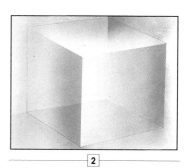

2

Follow the first three steps of the previous exercise to establish the basic solid form of the cube. Mask the vertical line joining the back corners of the cube. Spray graded tone against the masked edge extending only to halfway down the top plane **1**. Mask the ground plane of the cube and spray very lightly with graded tone to create the receding lines of the ground plane behind the vertical surfaces **2**. When complete, remove the background masking **3**.

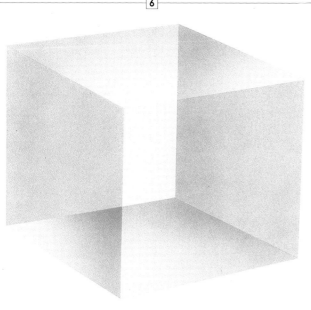

7

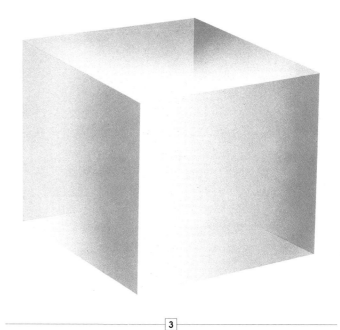

3

STEMMED WINE GLASS: HOLLOW AND SOLID GLASS

The elegant shape of a wine glass provides an exercise in airbrushing that includes various visual ingredients that the airbrush artist may confront in other contexts. All surfaces of the glass are curved: the bowl is a complex shape relating to both the basic cylinder and the sphere, and it is also hollow, demanding careful attention to highlight and shadow detail; the stem of the glass is fundamentally a solid cylinder; the base is a heavy glass disc with a slightly convex upper surface. Because of the fineness of the material, the detail is extremely intricate in places. To capture this effect, the airbrush work is complemented by hand-painted elements.

This is essentially a monochrome exercise, using black and gray tones of transparent watercolor to build up the image. Film masking emphasizes the clean structure of the wine glass – a good line drawing is all-important as the starting point, providing the fluidity and symmetricality of the form – but the hand painting and scratched-back highlighting subtly interrupt the basic framework of tonal values to recreate the unexpected but descriptive detail caused by the reflectiveness of the material.

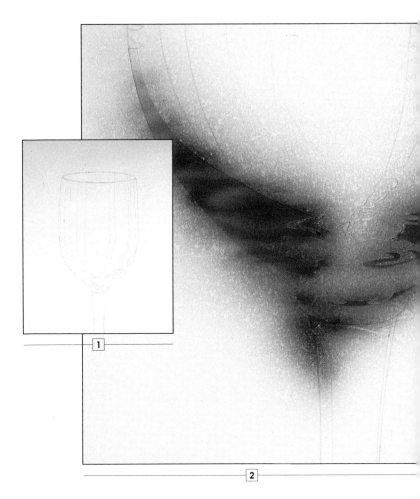

Make a detailed drawing of the image in outline, showing the basic shapes that form the darkest tones and highlights in the glass bowl stem and base **1**. Transfer the drawing to artboard so that the lines show only faintly; keep the original drawing to hand as reference while applying the airbrushed color. Cover the whole surface with masking film. Cut and lift the mask sections on the areas of darkest shadow at the bottom of the glass bowl. Spray freehand to create a soft "watered" pattern of black and dark gray **2** in the main area of shadow, and dark tone in the fine details.

Work down the stem of the glass in the same way applying the darkest-toned details. Cut and lift the mask from the strips of shadow on the sides of the bowl and spray with graded tone **3**. Peel back the masking film from the left-hand side of the stem base **4**. Spray with graded tone. When dry, replace the mask. Apply mid-toned shadow on the right-hand side of the base **5** in the same way. Remove the masking film from the stem base, except the areas to be highlighted, and spray lightly graded tone **6**.

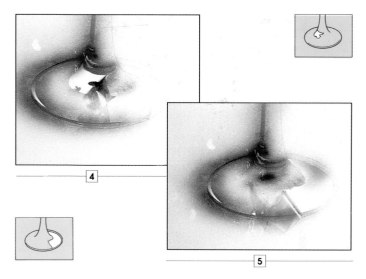

4

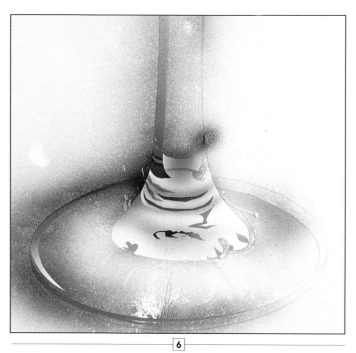

5

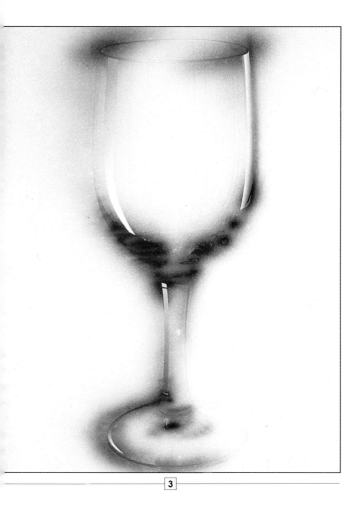

3

6

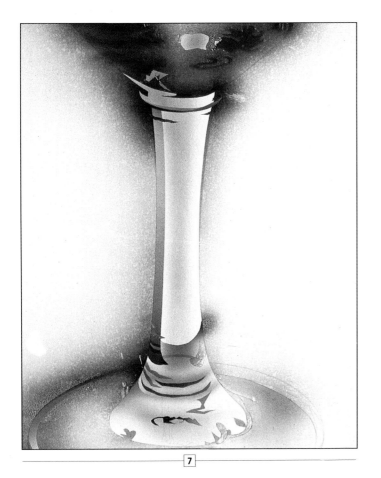

7

8

9

Remove the masking film from the stem of the glass and spray a graded mid-tone down the length of the stem **7**. Lift the strips of masking film from the outer rim of the glass base and apply graded tone **8**, darker on the left than on the right. Unmask the central area of the base, except for the fine highlighted shapes, and apply graded tone to emphasize the circular form **9**. Remove the remaining mask pieces to reveal the highlights. Then lift the masking film from the main area of the glass bowl **10**.

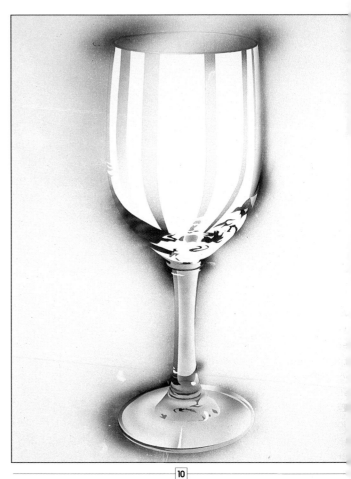

10

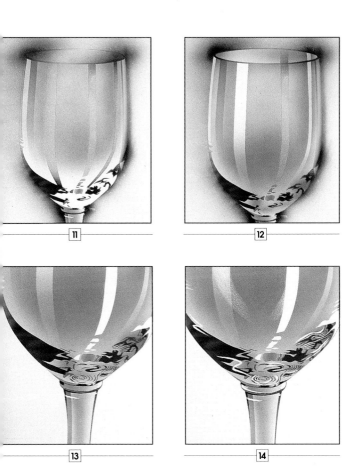

11

12

13

14

Working from the top to the bottom of the bowl, spray graded tone over the whole area, lightening toward the base **11**. Remove the sections of masking film from inside the ellipse at the top of the bowl. Spray graded tone darkest at the top right-hand edge and lightest across the ellipse shape. At the same time, remove masking from the left-hand highlight area and darken the tone at the base of the bowl **12**. Lift the masking from the shapes representing the main highlights. Work over the shadow detail in the base of the bowl using a fine paintbrush to increase the intricacy **13**. Use a scalpel to scratch back highlight detail in the bowl **14** and stem base. Remove all remaining masking film **15**.

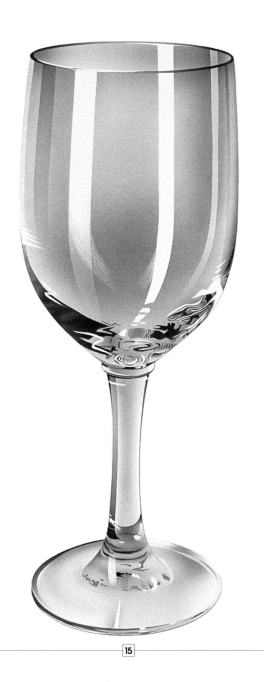

15

CAR WINDSHIELD: LEVELS OF TRANSPARENCY

Automobile art is a major area of airbrush rendering, providing the opportunity to exploit a range of surface effects that produce an attractive and impressive image. Frequently, the car windows are depicted as reflective elements, bringing a surface coherence to the image in the smooth transition between glossy paintwork and glass. In this example, however, the image is contrived to emphasize the contrast between the reflective paintwork and the transparency of the glass, showing the interior detail and framework of the car.

The frontal view of the car provides little information on depth and perspective, so explanation of the various levels of the car body depends upon an accurate initial drawing that establishes the sense of recession. The airbrush spraying, building the image from front to back, follows a conventional sequence from dark to light, laying in heavy shadows first, then mid-tones, before moving onto the highlight areas and final visual details. The overall tonal values and contrast between dark and light must be carefully balanced in each area of the image, to avoid the glossy paintwork becoming the dominant effect.

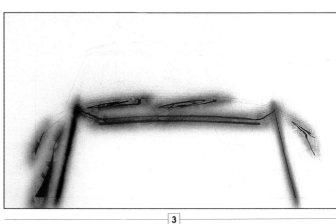

Make a detailed outline drawing of the image **1**. Transfer it to artboard, using tracing or transfer paper to make a faint line, and cover the whole image with masking film **2**, allowing a border area. The steps on these pages consist of building up the reflective surface on the paintwork of the car, before moving to the transparent windshield (see page 27 for the finished effect). Cut the masking film along the main lines of shadow on the car hood and on the windshield wiper reflections. Remove the mask sections and spray with dark blue **3**.

Lift the masking film from the heavily mid-toned areas on each side of the car and spray over the horizontal surface from the right-hand side. Spray each area with an even tone of blue **4**. If the image is sprayed using transparent watercolor, the full area is worked as a sequence passing from the darkest tones to the lightest, so there is no need to replace the previously lifted masks at each stage as successive sprayings do not affect the darker tone already in place. Continue with the slightly lighter areas of mid-tone, again spraying flat color **5**.

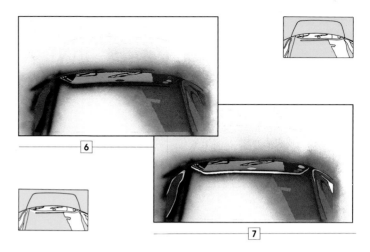

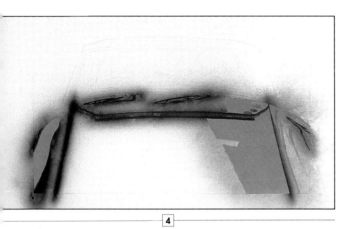

4

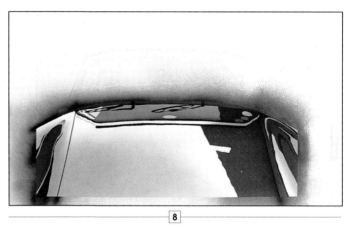

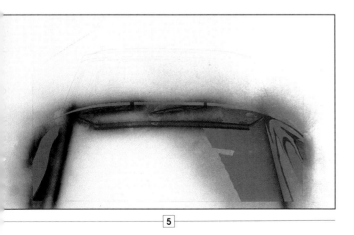

5

8

Remove the mask section from the hood area directly below the windshield. Spray with a flat tone of blue, to a less heavy density than in the previous step, forming the lighter range of the mid-tones **6**. Lift the masking film from the areas of light tone on the car paintwork, the line below the windshield reflection and the high tone on the car side **7**, and then the main area of light tone across the front and left-hand side of the car hood. Work all these areas with graded, pale tones of the same blue, distributing the color as shown **8**.

LEVELS OF TRANSPARENCY

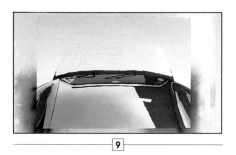

9

Allow the color to dry completely. Remask the shape of the car bonnet, and remove the masking film from the background area within the picture frame. Spray the background with a graded tone of sky blue, dark at the top and lightening toward the center of the image **9**. In the top section of the car, cut and lift all the pieces of masking covering the areas of the window that can be seen right through in the final image **10** (refer to page 27 to identify these areas). Spray with a graded tone of sky blue; allow the color to dry and remask the top section with clean film.

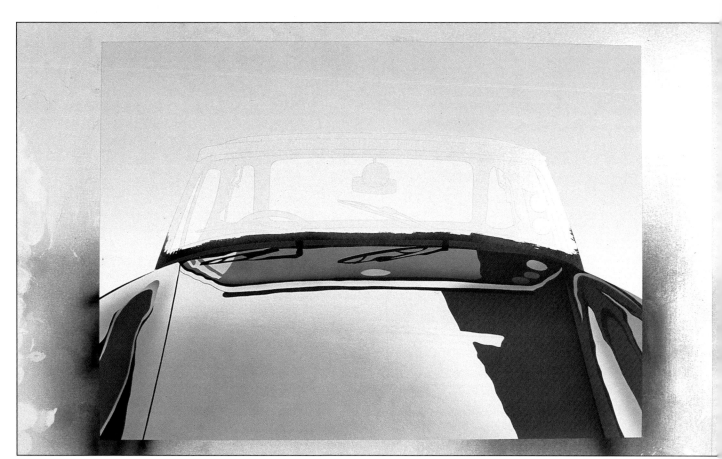

10

Remove masking from the lines of shadow along the top and bottom edges of the windshield. Spray with a graded tone of black **13**. Remove the sections of masking film covering the mid-toned shadows on the wipers and spray with graded tone. Lift the mask from the line across the roof of the car and spray with graded tone. Outline the form of the rear-view mirror by spraying freehand into the unmasked shape **14**. Unmask the mid-toned areas surrounding the left-hand windshield wiper and spray with graded tone corresponding to the mid-tones previously sprayed on the right-hand side **15**.

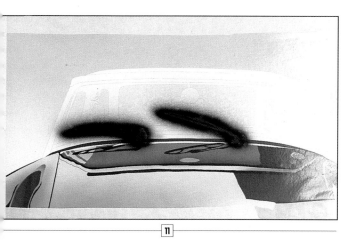

——— 11 ———

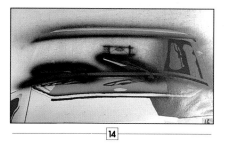

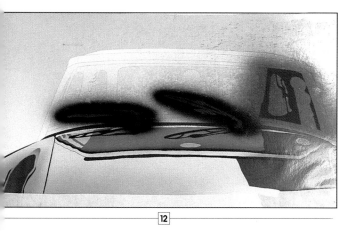

——— 12 ———

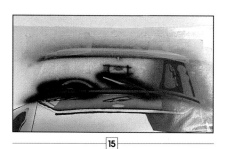

——— 13 ———

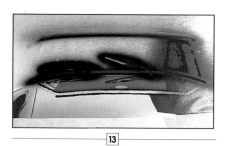

——— 14 ———

Remove the small sections of masking film from the silhouette of the windshield wipers, exposing all the areas of darkest tone. Spray overall with black to create a flat tone within each shape **11**. Cut the masking film along the lines outlining the darkest shadows on the right-hand side of the car, where the side window is viewed through the windshield (handle the scalpel lightly when cutting these intricate forms, to avoid marking the surface below with the knife blade). Spray with an even tone of black, building up a flat layer of color **12**.

——— 15 ———

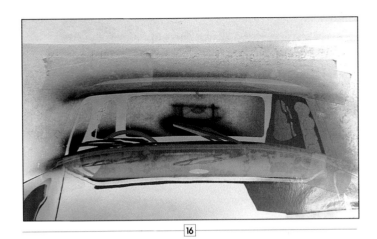

16

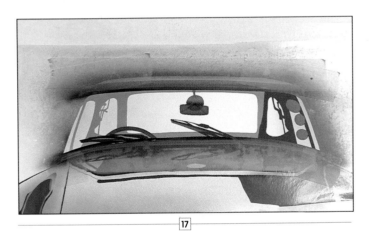

17

On the left-hand side of the windshield, spray finely with black against the edge of the masking to create a soft line of shadow. Take the shadow up to the top edge of the windshield and along the edge of the mask, grading it off toward the right-hand side of the windshield area **18**. Remove masking from the outer frame of the windshield, exposing the lines enclosing the basic shape. Spray with a lightly graded tone of blue-gray **19**. Before removing the masks, check the balance of tone overall. Lift the masks on the window stickers and apply hand-painted detail.

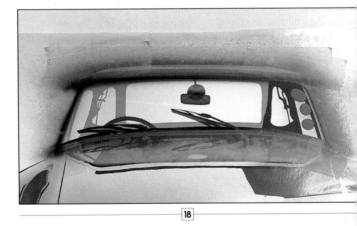

18

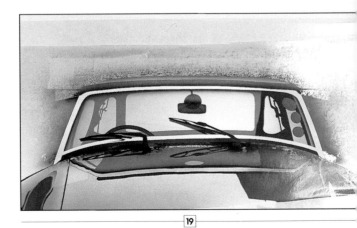

19

Apply tape or film masking to the roof of the car to mask off the upper edge of the windshield. In the same way, reinforce the masking right up to the lower edge of the windshield. Remove the mask sections from the framework of the window areas as seen through the windshield. Spray these areas with a flat mid-tone of gray-blue **16**. Allow the color to dry completely and remove all the remaining masking from the inner area of the windshield **17**, leaving only the side edges of the car framework masked, and the shapes of the licence plate and stickers on the windshield.

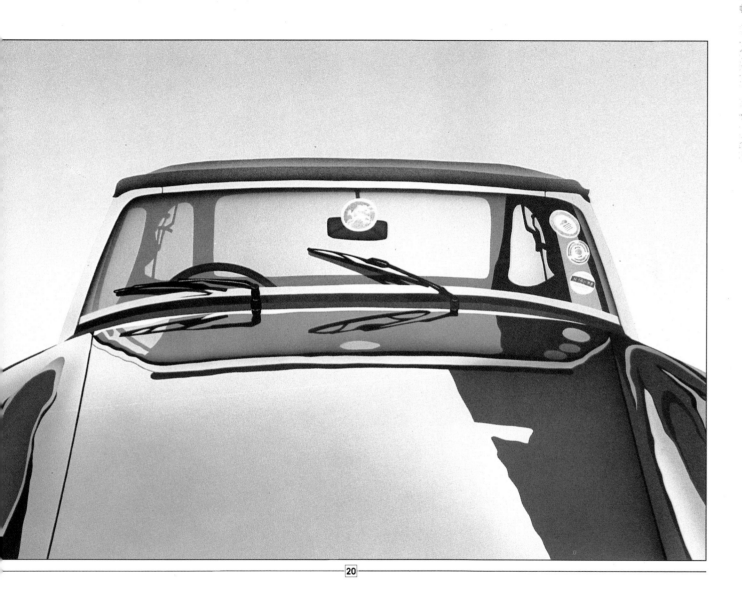

The final image shows the contrast of the glossily reflective painted surface leading into the detailed rendering of the windshield and view through the car body **20**. The detail of the stickers helps to establish the transparent foreground plane.

LEVELS OF TRANSPARENCY

SHEER CURTAIN: TRANSLUCENT FABRIC

The construction of this image provides a clear demonstration of the method of layering an image to build up a translucent effect. As can be seen from the step-by-step sequence, the detail of the window frame and panes is fully worked out before any attention is paid to the folds of the fabric curtain: these are sprayed on top of the previously completed work, almost as if the two elements were separate.

The majority of the image is built up using watercolor, which is itself a transparent medium; but the softness of the translucent curtain is achieved by spraying with opaque white, in fine layers that build up the veil-like effect, allowing the underlying color and shadows to show through indistinctly.

The image of the window is deliberately kept simple to allow the technique used in airbrushing the curtain to be clearly seen. The view beyond the window is only suggested by loosely formed shapes in colors implying sky and foliage. However, it is apparent that a more complex image could also be constructed in this way, defining the view outside in detail before applying the final "layer" of the curtain folds.

1

2

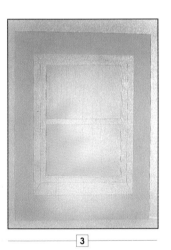

3

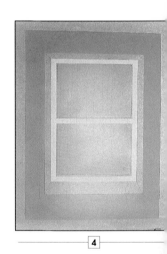

4

Produce an outline drawing of the image **1**, transfer it to artboard and cover with masking film. Cut and turn back the mask from the two window panes (hinge with tape for easy replacement). Spray a loosely outlined green shape, and blue across the top section of the upper pane **2**. Replace the masks and unmask the outer border of the window; spray with an even tone of gray **3**. When the color is dry, unmask the inner window frame **4**.

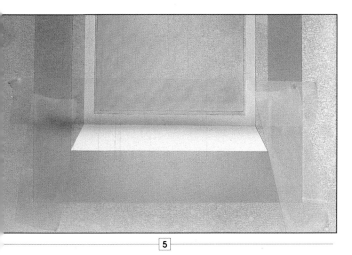

5

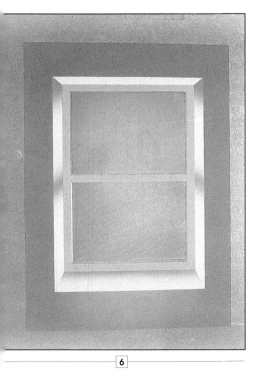

6

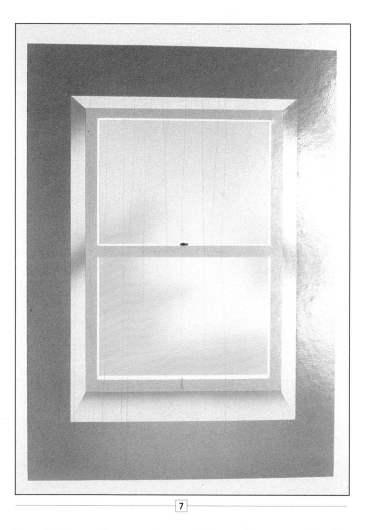

7

Spray the frame with an even tone of light gray. Remove masking film from the wedge shape of the sill; tape along the top to mask out the sprayed frame. Spray a graded tone of gray across the top edge of the sill **5**. Lift the masking from the side edges of the frame surround and spray central bands of mid-tone representing cast shadow; shade the top corners and remove remaining masking **6**. Allow to dry and apply fresh film overall **7**.

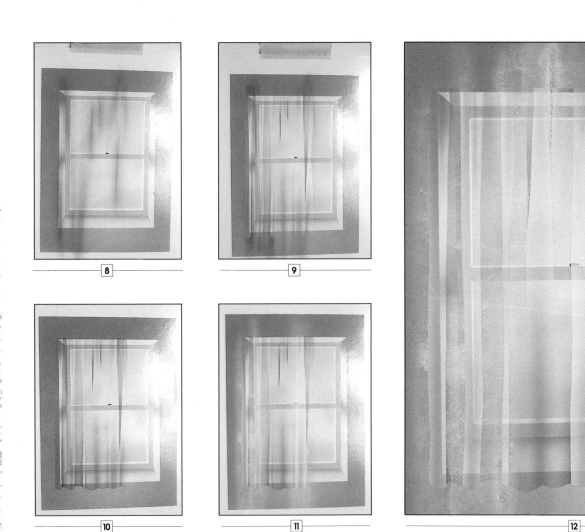

Cut the lines of the main folds in the curtains where a dark, hard-edged shadow appears. Lift the mask sections and spray with graded tone using black watercolor **8**. Remove masking film from the whole area of the curtain and spray mid-toned shadows **9**. Continue to build up the shadows gradually, spraying freehand and working from dark to light **10**. Replace masking over the main shadow areas and spray white highlights **11**.

With the main shadow areas still masked, continue to build up the opaque white spray, working over the mid-toned shadows but maintaining the translucency of the curtain by keeping the layers of white very fine and semi-transparent **12**. The highlighting is worked against the masked edges to create distinct outlines on the main folds of the curtains, in the same way that the shadows were previously applied using the transparent black.

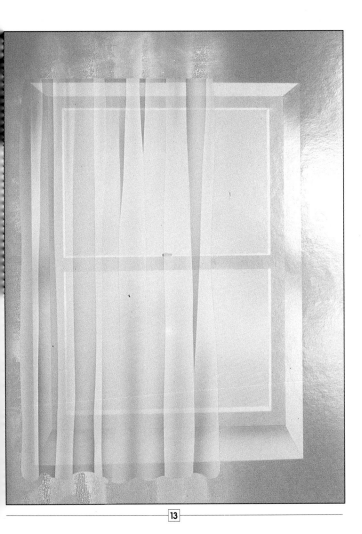

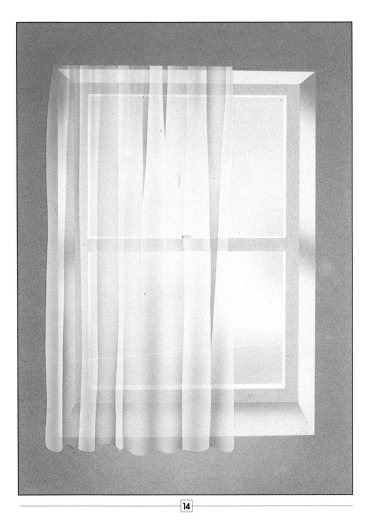

13

14

Remove the remaining film from the shaded curtain folds, leaving in place the mask covering the exposed area of the window and the background frame. Spray lightly with opaque white over the shadow areas to give the translucent effect, grading the tones to allow the modeling of the folds to remain well defined **13**. Keep the balance of tone evenly spread ᴛo avoid obliterating the definition of the shadows.

When the balance of tone is satisfactory and all the detail of the curtain folds fully modeled, allow the color to dry and remove all remaining masking film **14**. In the finished image, the translucency of the sheer curtain is set off by the hard-edged framework of the window, with the suggestion of color beyond the window panes establishing a third layer within the picture plane, although without a clearly defined form.

TRANSLUCENT FABRIC

PAPER GLOBE LAMPSHADE: RADIANT LIGHT

The lampshade in this image is of the type that consists of thin paper stretched over a framework of wire ribs. This forms a translucent effect when the lamp is lit, masking the source of the light but emanating a radiant glow which is evenly spread by the spherical shape of the paper globe.

To indicate the direct source of artificial light within the shade, the radiance is built up with transparent tones of yellow merging into a strong white highlight area at the center of the globe where the light source is strongest. The glowing effect is enhanced by the halo of light surrounding the shade, which merges softly into the dark background.

The particular effectiveness of the image depends upon the contrast of tonal values and the careful grading of tones that is readily achieved through airbrush spraying. The transitions of light and shade are worked very softly to indicate the diffused light, using transparent watercolor to build the tonal values subtly. The image is, however, given a fine linear structure by the distinctive form of the lampshade construction — the strong outline and the network of ribs describing its spherical volume.

Draw the image in outline, inserting all of the wire ribs of the lampshade as they should appear in the finished artwork **1**. Transfer the drawing to artboard and cover the whole image area with masking film. Cut and peel back thin strips of masking film along the lines of the lampshade ribs and on the top and bottom rims, leaving the intervening spaces and background area fully masked. Using black watercolor, spray with graded tone, darkest in the center of the shade. Build up the color to form a black rim at the top and the bottom of the shade **2**.

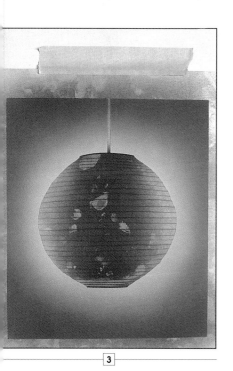

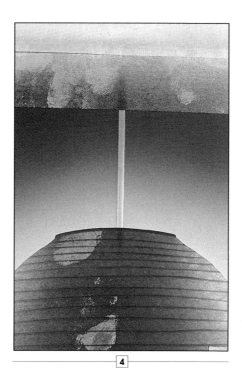

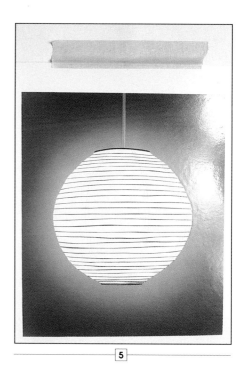

eeping the masking film in place within the circle of the shade and
n the light flex, remove the background masking within the
ectangular frame of the image area. The background is airbrushed
s a circular vignette around the shape of the lampshade. Charge
he airbrush with dark gray-blue and spray with a circular motion
rom the masked outer edges moving in toward the lampshade.
ngle the airbrush outward to avoid too much color falling around
he edges of the shade. Overspray the outer area of the background
o form a distinct tonal gradation from dark to light **3**.

Cut the masking film down either side of the line representing the
electrical flex passing into the top of the lampshade. Lift the strip of
film and spray with a graded tone of gray. Work freehand, keeping
the airbrush close to the surface, controlling the spray area within the
narrow shape to leave lines of highlighting on each side of the strip,
where the flex emerges directly above the lamp **4**. Allow the color to
dry completely, then remove the oversprayed masking film from the
lampshade and apply a clean piece of masking film across the
whole image area **5**.

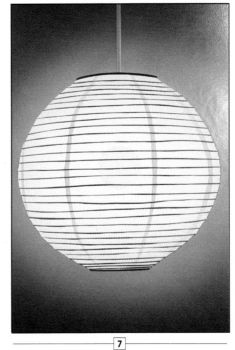

7

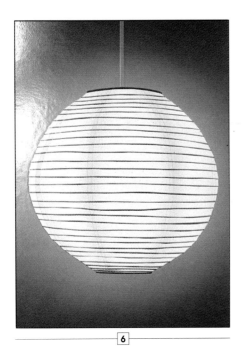

6

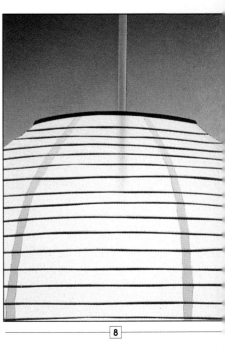

8

In the fresh mask, cut the lines of the vertical ribs of the shade and peel away the strips of masking film. Spray down each exposed strip with yellow watercolor, building up a strong, solid tone **6**. When the stripes of solid yellow are completely dry, remove the masking film from the remaining sections within the lampshade. Using the same yellow, spray around the outer edges of the shade to form a semi-transparent mid-tone. Gradually increase the area of spray, pulling the airbrush back from the surface, to create graded tone encircling the white highlighted area at the center of the shade **7**.

Judge the tonal balance of the yellow light against the haloed area of light surrounding the shade. Clean out the airbrush and recharge it with gray watercolor. Working freehand and keeping the airbrush close to the surface, spray a faint, soft-edged line of gray from the top of the shade, indicating the shadowy line of the electrical flex passing inside the paper globe **8**. If necessary, turn the artwork to site the flex horizontally and use a ruler to guide the airbrush in line with the solid strip of the flex already sprayed. The line should disappear softly at the bottom.

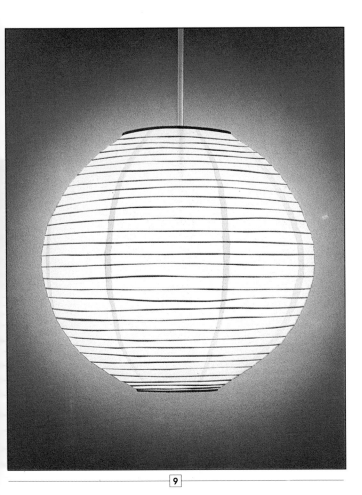

<div style="text-align:center">9</div>

GLASS OF ORANGE JUICE JOHN CHARLES

This is a delightfully fresh image wholly in keeping with the character of its subject. The heavy translucency of the juice is suggested by soft gradations of tone, contrasted with the hard highlighting and surface pattern elements of the clear glass container. In the slice of orange, too, there is a successful contrast between the lushly transparent flesh of the fruit and the solid pith and rind.

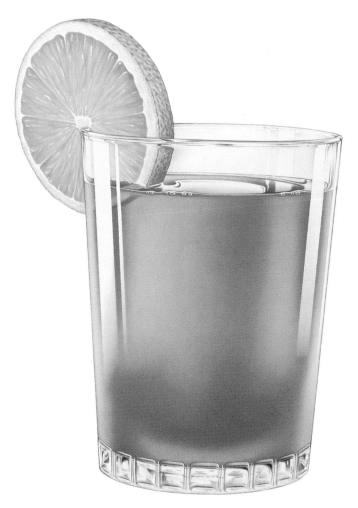

When the spraying is completed, allow the color to dry and remove the remaining masking film from the background area of the artwork. The completed image **9** should provide a convincing effect of radiant light emerging from the lampshade, so that the combination of the yellow light inside the shade and the halo of white light spreading into the background causes the effect of a glowing lamp. This depends upon the correct balance of tones and the softness of the transitions in the graded tones passing over the hard-edged ribs that form the basic structure of the lamp.

SUNGLASSES: SCREENED GLASS EFFECT

The fine quality of airbrush spray allows the artist to layer the image very effectively, so an apparently complex effect of translucency can be achieved by a simple method, in this case the final spraying of a flat tone within the lens of the sunglasses. This image in fact demonstrates the importance of the observation of underlyiing detail behind a transparent or translucent plane. In the step-by-step sequence, the majority of the work is concerned with developing the framework of the image and the detail of the face, before the final effect of the glass lens is applied. But the effects of light and shade are continuously affected by the fact that the smoky glass plane is the focus of the image, so the modulation of flesh tones and shadows is assessed on this basis, not quite as it would be seen if the sunglasses were not part of the portrait.

The basic color areas and modeling of light and shade are built up entirely with airbrush work using film masking. However, as is common in airbrush work, a few important details are applied with hand-painted brushwork and by scratching back highlights with a scalpel in the final stages of the artwork.

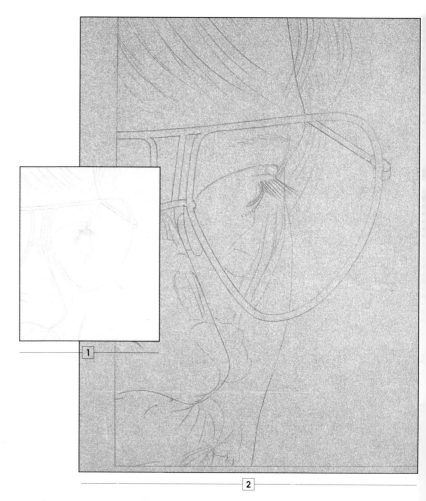

Make a detailed outline drawing of the image **1**. Transfer it to artboard using tracing or transfer paper **2** and cover the whole image area with masking film. Lift the masking from the background area, leaving the outline of the sunglasses masked, and spray the background area with a graded tone of sky blue **3** lightening toward the lower edge of the image. Remask the background when the color has dried completely. Cut and lift the masking from the frame of the sunglasses and spray with a dark gray tone **4**.

3

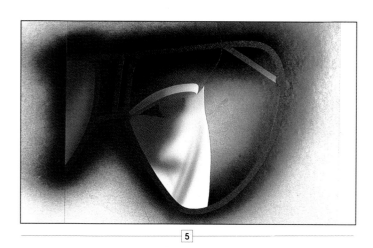

5

Remove the masking from the main shadow areas around the eye, leaving the sections that will show pale color still masked. Spray with a dark sepia tone. Unmask the remaining area of the face within the shape of the glasses lens, except highlight detail in the eye. Spray freehand to develop the mid-tones and soft-edged shadows **5**. Remove the remaining masking and apply light tone to the inner corner of the eye, and under the eyebrow merging into the highlighted edge **6**.

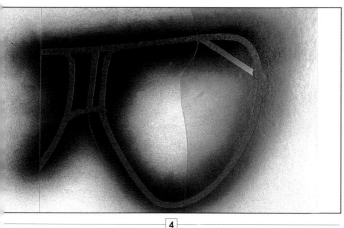

4

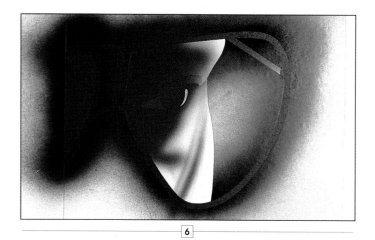

6

SCREENED GLASS EFFECT

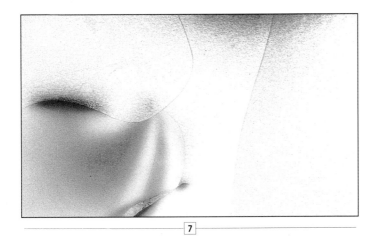

7

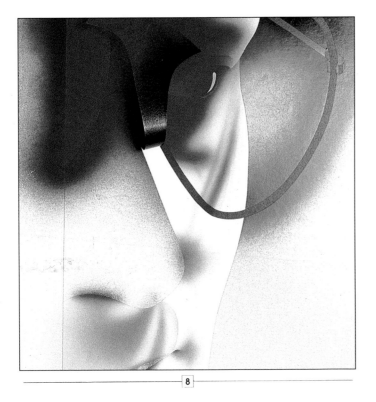

8

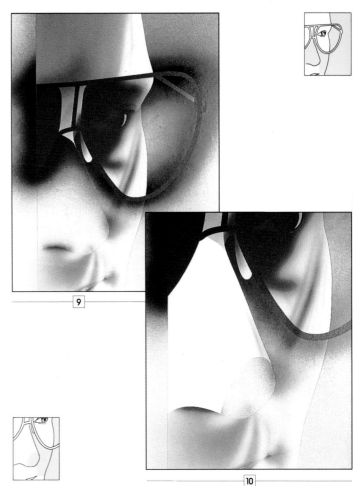

9

10

Lift the mask section below the nose and spray freehand with the same sepia tone to create dark shadows and mid-tones **7**, working against the hard edges of the masking at the top and right-hand edges of the shape. Follow the same process to establish the facial modeling in the lower part of the face **8**, the forehead above the sunglasses, and the bridge of the nose behind the frame of the glasses **9**. Work each section in turn referring to the balance of tone in the previously sprayed area.

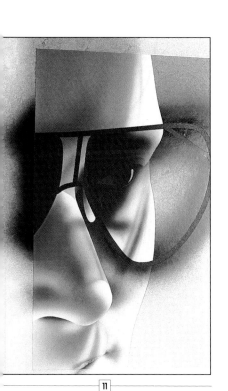

11

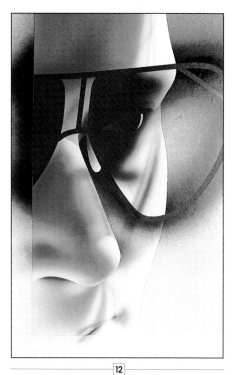

12

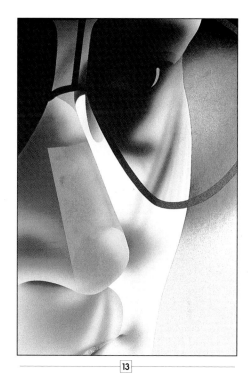

13

eplace the mask over the lower side of the face and remove the nal piece of masking from the nose area **10**. Spray in the dark hadows, working freehand close to the surface to emphasize the ard-edged line over the nose representing the cast shadow ormed by the frame of the glasses **11**. Check the overall effect of he tonal balance in the modeling of light and shade across the ace and make any necessary adjustments before moving on to the ext stage.

Recharge the airbrush with flesh color and overspray the forehead, nose and outer edge of the cheek with a glaze of warm tone, working over the previously applied sepia-toned shadows **12**. Keep the glaze light and even to allow the shadow modeling to show through clearly, and fade the color into the main highlight areas. Lift the mask section on the right-hand side of the face below the glasses and mask off the outline of the nose. Spray the flesh-colored glaze over this area **13**

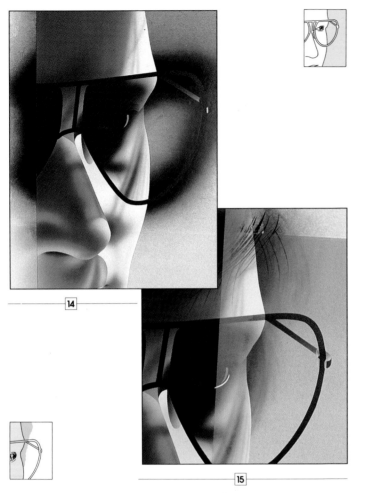

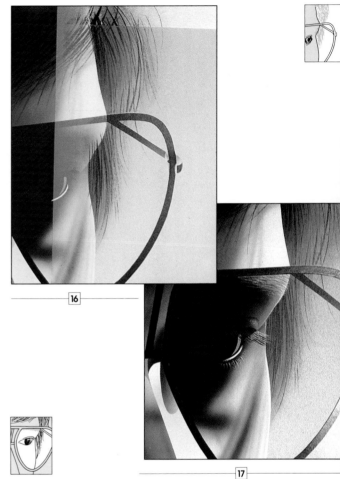

Continue to model the flesh tones using the warm glaze of color to overlay the shadows, completing the lower part of the face in the same way as the other sections **14**. Using a fine paintbrush and brown-black paint mixture, draw in fine lines of dark tone representing the hair on the forehead. Soften the effect with a fine spray of the same color. When dry, remove background masking and mask the side of the face with film or transparent tape **15**.

Apply the wisps of hair against the side of the face, working over the background color with the fine paintbrush and again using airbrush spray to soften the linear effect **16**. Strip off the temporary masking from the side of the face. Use a scalpel to scratch very finely into the dark tone to produce the highlights in the eyebrows and eyelashes, combining this with carefully controlled brushwork to develop more fully the texture of the individual hairs **17**.

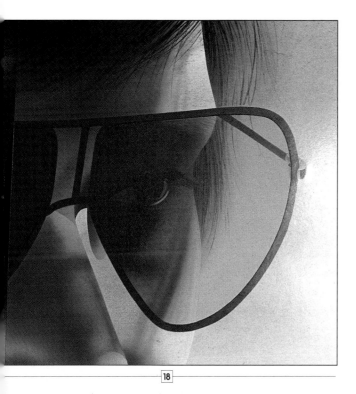

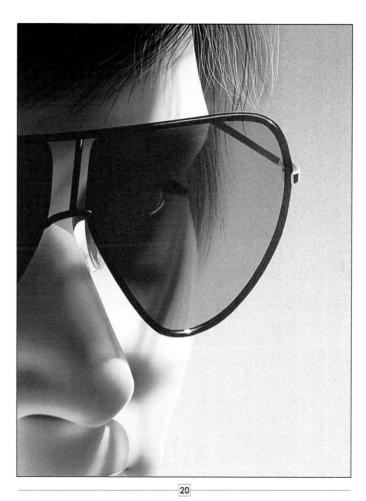

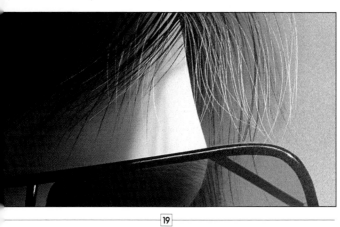

Allow all the color to dry and remask the whole image with a clean piece of masking film. Cut and lift the inner shape of the lens. Spray flatly with a yellow-tinged sepia tone to make the effect of the smoky glass over the modeled forms of the eye and flesh tones **18**. Remove masking and use a scalpel to scratch back final highlight details in the hair and glasses frame **19**. The completed image presents an effect of strong illumination, as in full sun **20**.

GREEN GLASS BOTTLE: TRANSPARENT COLOR

This is basically a monochrome exercise in which shadows and mid-tones are built up gradually through the system of masking and the main color of the image is applied as an overall glaze in the final stages.

The thickness of the glass bottle, especially in the base and neck, and the surface effect of the liquid in the bottle create dense, rich shadows and although these tonal values are the key to the full image, these shadows also have a distinctive hue of their own. They are modeled with a heavy blue-green, contrasting with the clear true green that represents the intrinsic color of the glass. This creates a bolder sense of visual depth than would be obtained by using black or gray in the underpainting and relying on the green glaze to modulate the surface, as the neutral tones could have a deadening effect. Accurate analysis of color values within a transparent object provides a convincing rendering and also enlivens the surface qualities of the image.

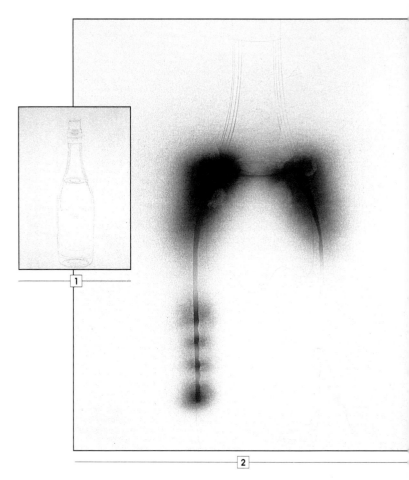

Make an outline drawing of the image **1**, transfer it to artboard and mask the image area. Remove the masking from the lines of shadow on the sides of the bottle and across the bottleneck where the surface of the liquid shows. Spray with a dark tone of blue-green grading the color to mid-tone at intervals where the shadow passes down the bottle sides **2**.

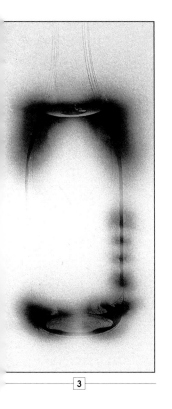

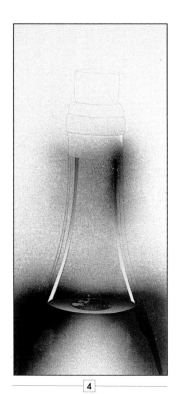

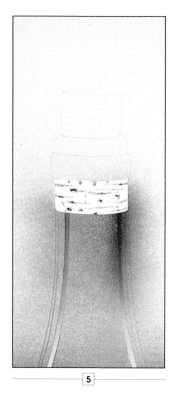

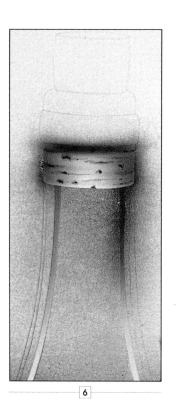

Repeat the process to apply the areas of heavy shadow at the base of the bottle, grading the dark tone toward a highlight area at the front edge **3**. Remove the strips of masking film covering the linear detail in the bottleneck and the elliptical surface of the liquid. Spray mid-tone in these areas, making the color gradation as shown in each section **4**.

Lift the mask section from the lower part of the cork and hand-paint the mottled brown texture using a fine paintbrush **5**. With the airbrush, overspray using a lighter tone of brown to create the tonal gradation across the cork **6**. Work freehand, keeping the airbrush close to the surface to control the area of spray but being careful not to apply too heavy a layer of color.

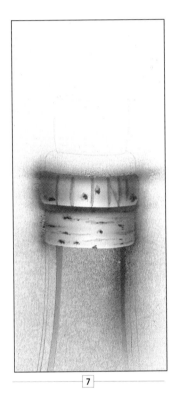

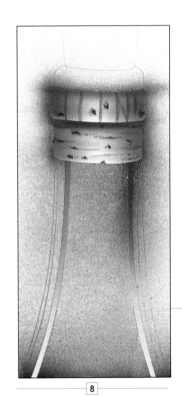

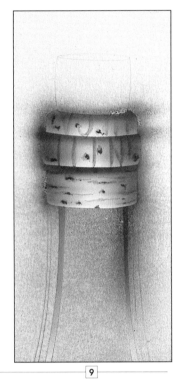

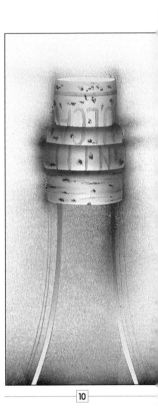

7

8

9

10

To simulate the glass passing over the cork, spray around the edges of the cork section with blue-green to modulate the color and create a shadowed rim **7**. Unmask the next section of cork and work up the texture in the same way, building up from hand-painted detail, through spraying the basic brown tone and finally to applying the blue-green shadow **8**.

Continue to build up the detail of the cork in the same way. Use the same technique as previously to apply the texture and color deta of the section under the upper rim of the bottle **9**. In the top section where the cork emerges from the bottleneck, follow the first two stages only, to apply the cork texture and the overall warm tone without modifying the shadows **10**.

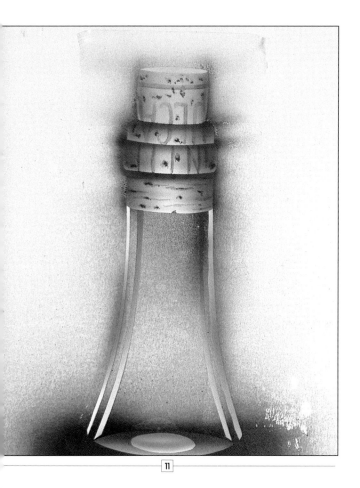

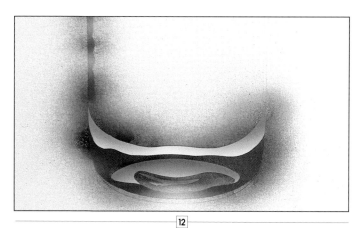

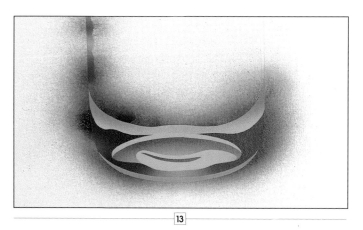

When the bottle rim and cork are completed, return to the neck of the bottle. Lift strips of masking tape following the outline of the form down both sides. Spray the central sections with green, grading the tone vertically from the center. Lift the elliptical piece of mask from the center of the liquid surface and spray with green, varying the tone to create highlight areas **11**.

Remove the mask from the main elliptical area at the base of the bottle. Spray with mid-toned blue-green. Lift the mask section above the heavy shadow area. Spray mid-tone across the top edges of the shape on each side **12**. Remove the mask section remaining in the base of the bottle. Spray a clear tone of pure green across all the unmasked areas of the bottle base **13**.

TRANSPARENT COLOR

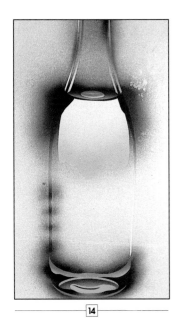

14

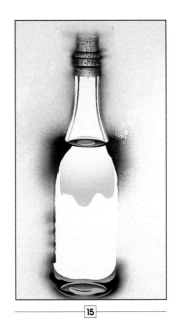

15

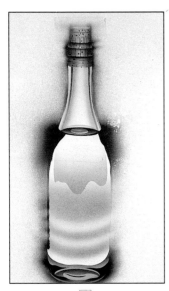

16

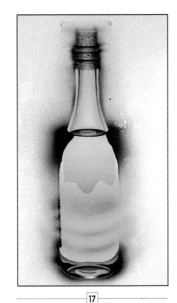

17

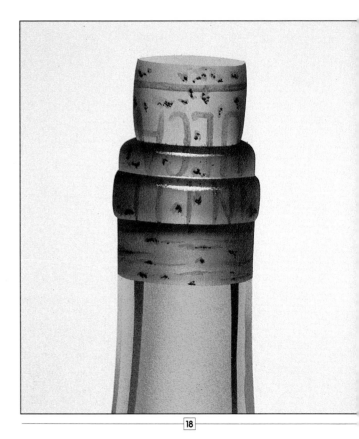

18

Uncover the central area of the bottle, below the ringed surface of the liquid. Spray a graded tone of light blue-green, working dark-to-light moving from the base of the shape **14**. Gradually build up the color to the required density of tone. Allow this to dry, and then remove all the remaining masking from the inside of the bottle, leaving only the background area masked **15**. Spray soft bands of blue-green vertically down the shape of the bottleneck. Apply a broad area of tone at the center of the bottle and two curved bands of tone below this **16**. Allow the color to dry completely before moving to the next stage. Spray green over the whole shape of the bottle, overlaying the blue-green tones **17**. Scratch back a highlight at the front edge of the base.

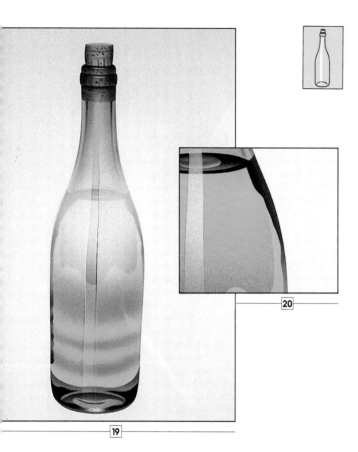

19

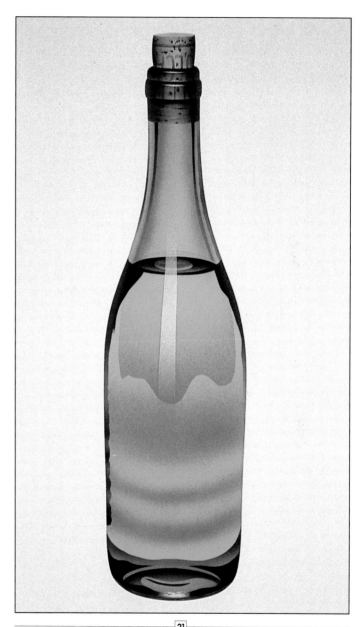

20

Create highlights on the rim of the bottle as shown by scratching back the color with the tip of a scalpel blade **18**. Make a loose mask from acetate or paper with a tapered strip cut vertically in the center. Apply the mask to the center of the bottle and spray through the cutout shape with opaque white **19**. Apply a delicate spray of white at the edge of the right-hand shadow **20**. The finished image **21** forms a coherent surface effect in which the dark shadows and white highlights are smoothly linked by the mid-toned areas in shades of green. This establishes the depth of the image, the opaque highlight defining the foreground curve while the heavy shadows indicate the thickness of the material and the completion of the curved form.

21

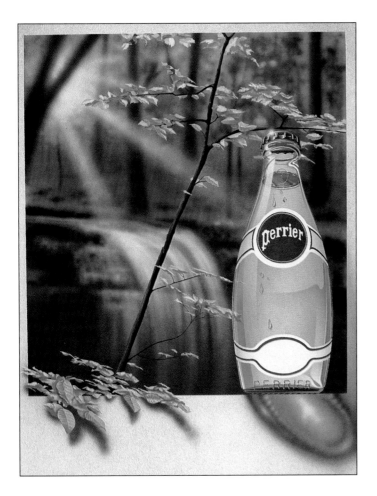

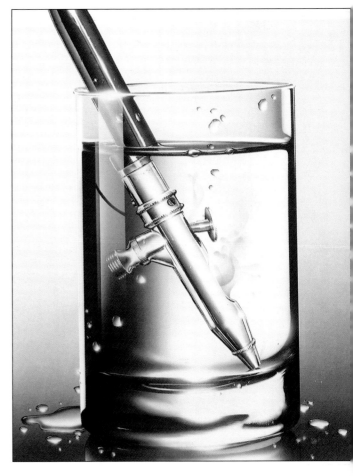

PERRIER BOTTLE JOHN SPIRES

The detail in this image is simplified and stylized to some degree, but provides the essential information to differentiate the textural qualities of each individual element. An interesting effect deliberately included is the colored shadow cast by the bottle which, like the object itself, gives a translucent glow. This links both with the leaves breaking the lower frame of the image and with the highlighting on the bottleneck leading through to the light rays from the forested background.

AIRBRUSH IN WATER TOM STIMPSON

This particularly apt image demonstrates the optical illusion which occurs when a solid object is viewed through a transparent medium. The mainly monochrome rendering of the airbrush and glass of water is enlivened by the fine threads of color issuing from the color cup of the airbrush into the mass of water. The heavy shadows emphasize the regular shape and thick base of the glass, while the water droplets add further interest to the range of detail in the image.

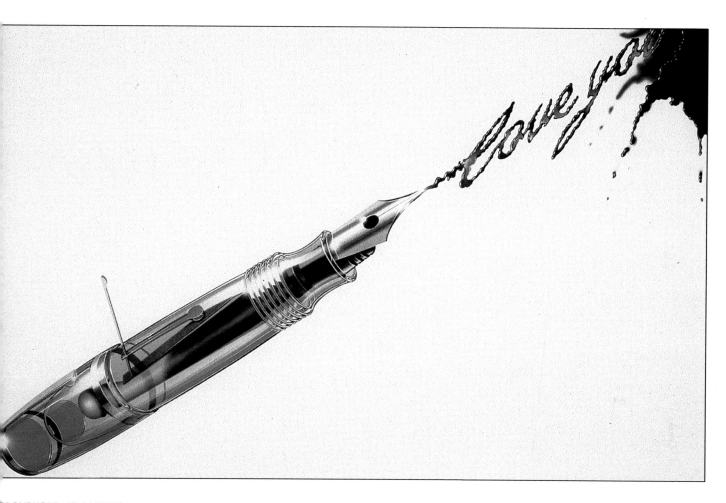

"I LOVE YOU" JOHN SPIRES

The image carries a message, but of more interest in this context is the careful detail of the fountain pen, its inner framework seen through the transparent casing. This allows the artist to trace the elliptical shapes running through the cross-section of the pen, and to increase the tonal depth of the image by including the dark band of the ink cartridge against the green casing and gold nib and case detail. This is particularly effectively seen against a broad expanse of white ground.

GLASS PRISM: COLORED LIGHT DISPERSAL

The effect of light transmitted through a prism is significantly different from the simple passage of light through a single transparent plane or a regular solid object. The thickness of the glass and the arrangement of angled and parallel planes in the prism have the result of dispersing white light into its component colors, creating the special rainbow effect associated with prismatic form.

Color is an element of transparency that can be employed to enliven a representation, especially when introduced sparingly to offset the subtle effect of a mainly monochrome image. Although the controlled dispersal created by a prism, which is a precision-made object, is not strictly applicable to other regular or irregular transparent forms, there are comparable color effects under certain conditions that can be exploited visually.

The rendering of the prism depends upon the use of watercolor, a paint medium which itself has the quality of transparency enabling the rainbow effect to be represented subtly but with clarity. This area of the work is also sprayed freehand, providing additionally a useful exercise in airbrush control.

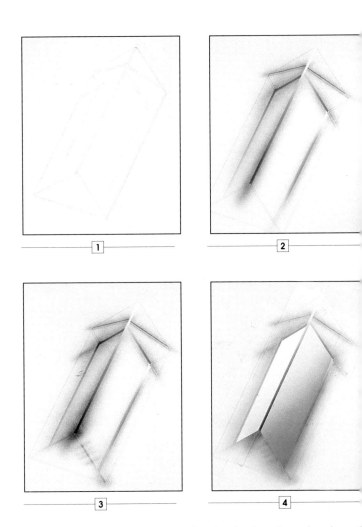

Draw the prism in outline, transfer the drawing to artboard and cove with masking film **1**. Cut and lift the mask along all lines representing the junction of planes in the prism. Spray the exposed bands with graded tones of gray **2**, working dark to light in opposite direction alternately. At the leading triangular plane forming the front face of the prism, spray graded tone along the length of the left- and right-hand edges, but also work crossing bands of darker tone on the right-hand edge **3**.

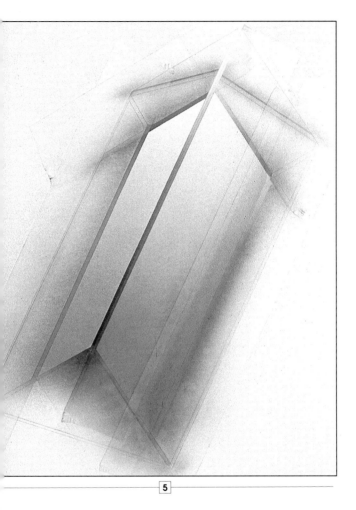

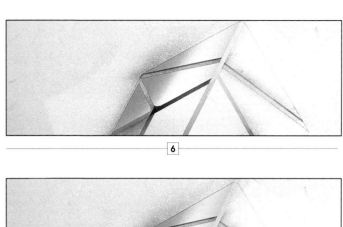

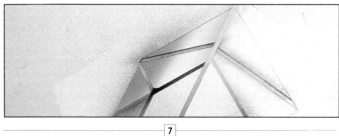

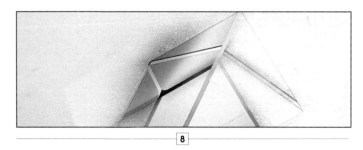

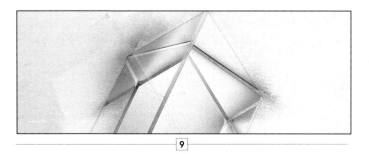

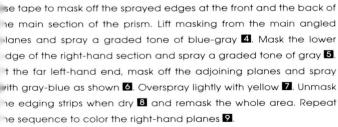

se tape to mask off the sprayed edges at the front and the back of
he main section of the prism. Lift masking from the main angled
lanes and spray a graded tone of blue-gray **4**. Mask the lower
dge of the right-hand section and spray a graded tone of gray **5**.
t the far left-hand end, mask off the adjoining planes and spray
ith gray-blue as shown **6**. Overspray lightly with yellow **7**. Unmask
he edging strips when dry **8** and remask the whole area. Repeat
he sequence to color the right-hand planes **9**.

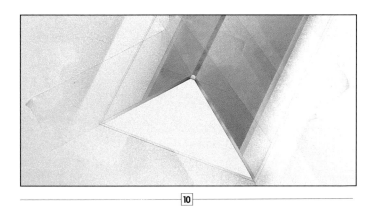

10

12

13

14

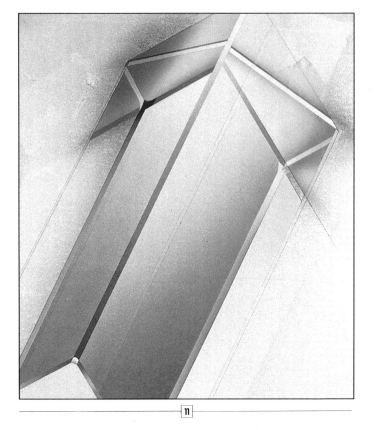

11

Allow the color to dry completely between each stage to avoid damage to the surface finish when remasking. Use tape or film masks when sectioning off different areas of the image. Mask off the triangular front face of the prism and spray lightly with an even tone of warm beige **10**. Remove any masking overlapping the right-hand long side of the prism. Mask off the lower section on that side and spray with a light tone of blue-gray, darkening slightly toward the far end of the section **11**. Mask off the corresponding lower section on the left-hand face of the prism. Spray a very fine transparent band of blue just forward of the center of the plane. Overspray the leading edge with a fine layer of purple **12**. Spray green behind the blue band, followed by yellow **13**. Allow each band of color to overlap forming a smooth gradation from one hue to another. Continue by working a band of orange, then red, until the length of the plane is filled with a translucent rainbow of color **14**.

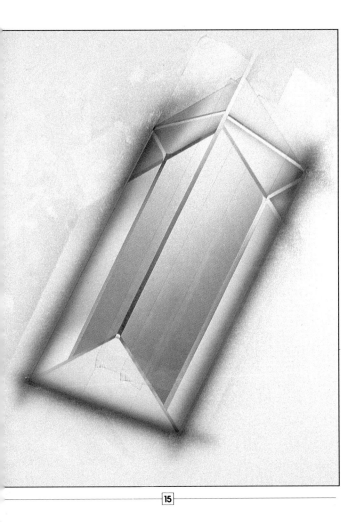

15

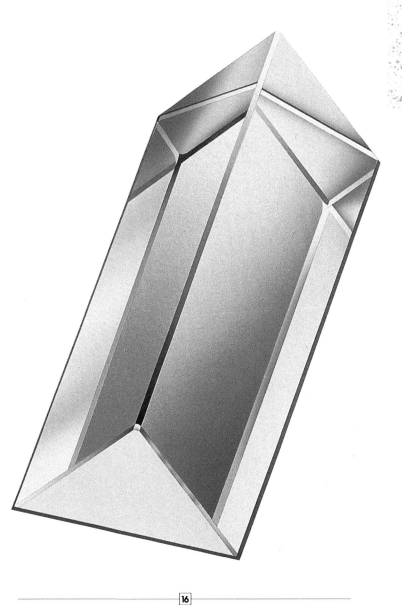

16

sing tape or film masking, cover the central area of the prism, masking off the lower edges on the left-hand side, front and ght-hand side. Spray the three edges very finely with black to lay in light to medium tone corresponding to the graded tones on the ther plane edges. Overspray with red, working evenly along each dge **15**. When the color is dry, remove all the remaining masks om the prism and the background area, revealing the clear shape nd color of the object **16**.

WATER DROPLETS: REFLECTION AND TRANSPARENCY

The surface of a colorless, transparent liquid paradoxically produces a rigidly defined, hard-edged effect of high tonal contrast in this example of water droplets lying on a colored surface. The blue tone of the droplets is color seen through the liquid, balanced on the one hand by strongly shadowed edges, indicating the shape of the droplet on the surface, and on the other hand by pure white highlights of very distinct outline, giving the effect of total light reflection from the surface of the water.

These elements define the keen-edged but irregular shapes formed by the separate drops of water and the slight curvature of the surface caused by the tension of the liquid. From the technical point of view, this is a relatively simple exercise in airbrushing, but one that is surprisingly effective in visual terms. The liquid has to be described in its own terms, because of the minimal visual reference provided by its surroundings. Compare the complex effect of refraction, the soft and hard shadows broken up into intricate shapes, which appear in the project following, where the subject is a greater mass of water contained within a regularly shaped vessel.

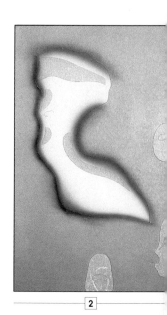

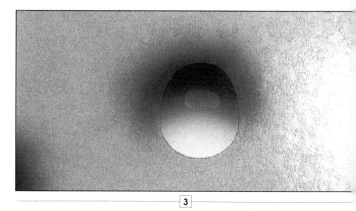

Draw the image in outline, transfer it to artboard and cover with masking film. Remove the masking from the background area and spray with a graded tone of blue **1**. Replace background masking and unmask the droplet shapes in turn, leaving highlight areas and edge shadows masked. Spray dark tone around the edges of the large shapes **2**. Model the rounded droplets with graded tone **3**.

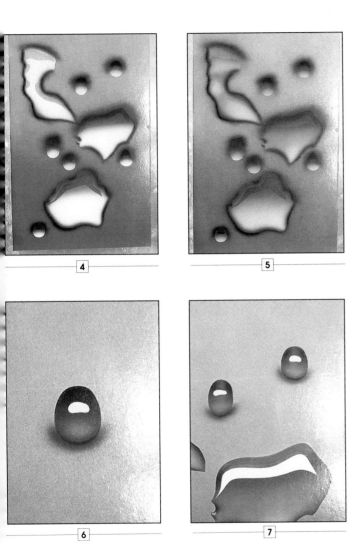

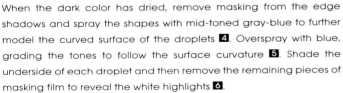

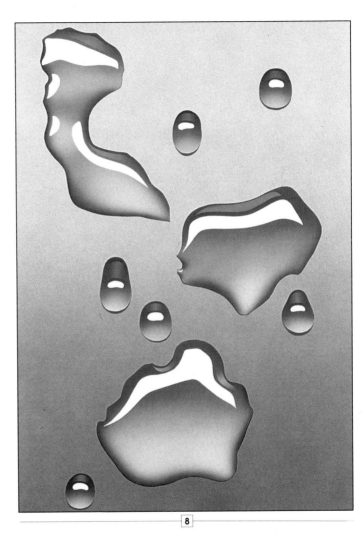

When the dark color has dried, remove masking from the edge shadows and spray the shapes with mid-toned gray-blue to further model the curved surface of the droplets **4**. Overspray with blue, grading the tones to follow the surface curvature **5**. Shade the underside of each droplet and then remove the remaining pieces of masking film to reveal the white highlights **6**.

Before lifting the background masking, adjust the balance of tone in each shape, giving the rounded droplets an almost spherical effect by applying dark tone opposite the highlighted edge **7**. When the balance of tone is satisfactory and the liquid effect of the droplets clearly rendered, peel away the masking film covering the background tone to leave the clean-edged completed image **8**.

REFLECTION AND TRANSPARENCY

BRUSH IN WATER:
EFFECT OF REFRACTION

This relatively complex image demonstrates significantly the fact that transparency is not a property that can be defined in isolation, but depends upon the quality of the transparent material, its effect on solid objects seen through or within the transparent medium, and the interaction of the ways in which the various elements transmit or reflect light. The image introduces the physical phenomenon of refraction – in this case, the distortion of the linear shape of the brush where it is seen through the thick glass of the jar rim and at the surface level of the water in the jar. The fracturing of the solid shape of the brush also establishes the different levels of recession from the picture plane.

Successful representation of an image of this type depends upon careful observation of the intricate details of light and shade which construct the overall effect of transparency. These are built up from dark to light, spraying mainly with transparent color, but there are some important final details which need to be applied by hand, rather than with the airbrush, that activate the picture surface and complete the authenticity of the rendering.

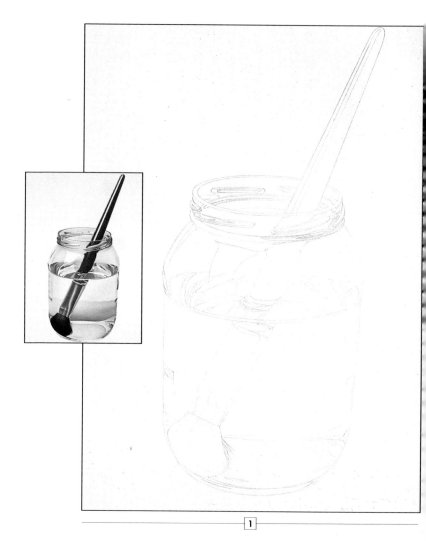

Make a detailed line drawing of the subject showing the basic outlines of each shape and the main areas of highlight and shadow, particularly the detail on the rim and base of the glass jar and reflections on the water surface **1**. Transfer the drawing to artboard, providing faint guidelines that will not interfere with the spray quality, and cover the image with masking film.

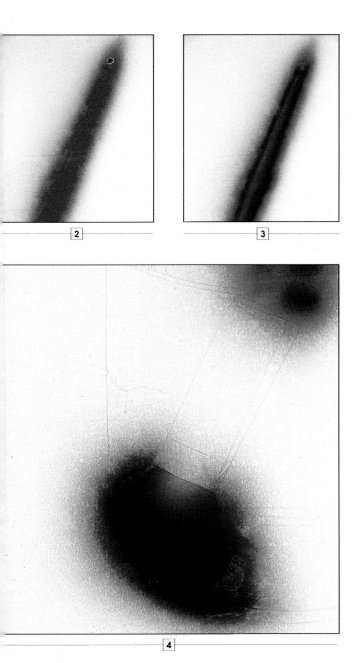

2

3

4

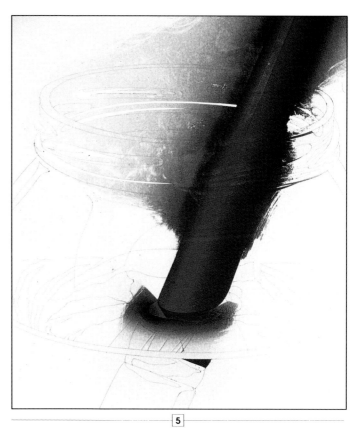

5

Cut and lift the mask from the main areas of the brush handle, leaving highlight areas on the handle and jar rim masked. Spray with dark red **2**. Overspray the edges of the same shapes with black to model the rounded shape of the handle **3**. Refer to the finished picture on page 61 as necessary at each stage of spraying to identify the balance of tonal values in each section of the artwork. Remove masking film from the shape of the brush bristles, treating this as a single color area. Spray with sepia, grading the tone to form heavy color at the ends of the bristles lightening toward the junction with the metal ferrule **4**. Cut and lift the masking film from the shadow detail on the rim of the jar **5** and spray with finely graded tones of black watercolor.

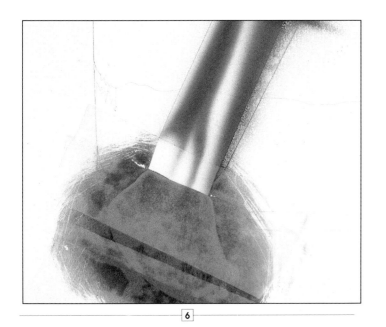

6

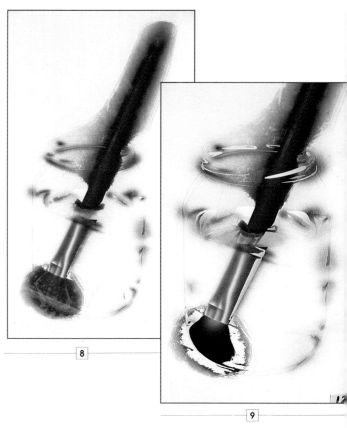

8

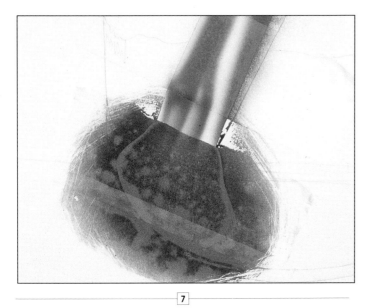

7

9

Unmask shadow detail in the surface of the water surrounding the shaft of the brush and spray with graded tone. Remove masking from the main section of the metal ferrule of the brush and spray vertical bands of tone to model the rounded form **6**. Mask separately the crimped edge of the ferrule and spray freehand to form soft lines of graded tone indicating the change of angle **7**. Remove the remaining sections of masking from the ferrule to reveal the tonal values clearly. Cut and lift masking from the shadow detail down the right-hand side of the glass jar from rim to base. Spray with graded tones of black watercolor to create the shadow areas **8**. Refer to the elements now in place to form the tonal key for the remainder of the image.

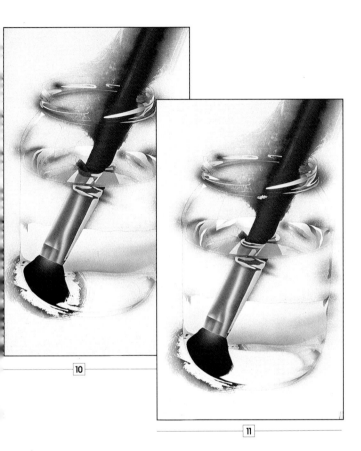

Lift masking film from all the areas of the glass jar that include mid-toned shadow detail. Spray with an opaque gray mixed from white and black, to contrast with the transparent quality of the watercolor. Apply areas of solid or graded tone as appropriate **9** to build up the tonal variations. Remove the masking from the broad band of mid-tone above the base of the jar and spray with graded gray **10**. Using transparent gray, overspray shadow detail at the top end of the brush ferrule to modulate the tones in the area where the water causes refraction in the line of the brush. Remove masking from the main section at the base of the jar and spray with graded tone **11**. Lift mask sections at the base and rim of the jar and enhance the detail of dark and mid-tone **12**.

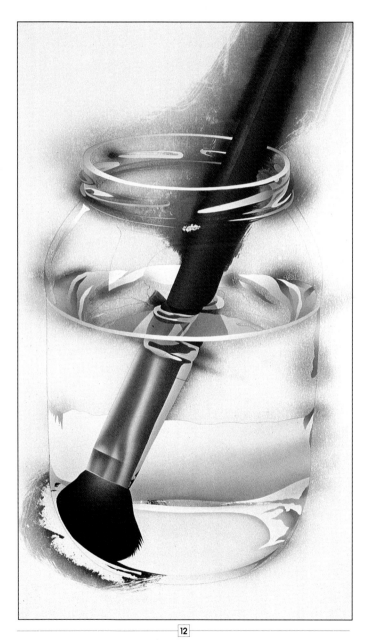

EFFECT OF REFRACTION

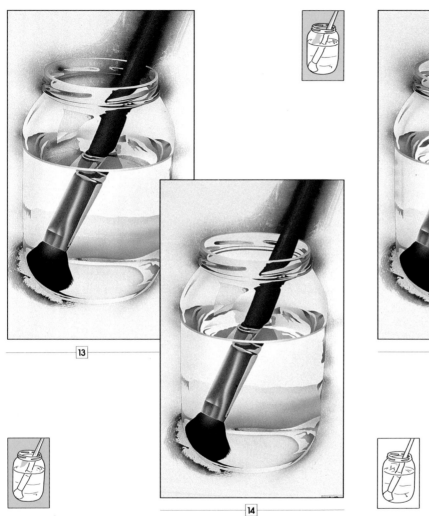

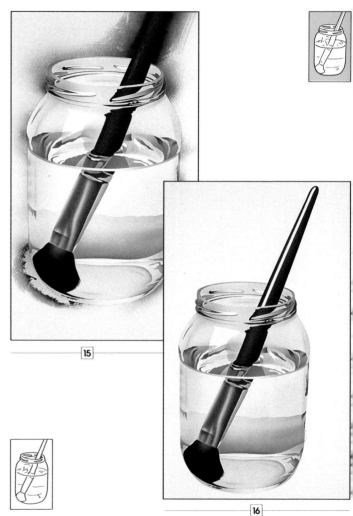

Remove all the masking from the outer rim and body of the jar except those sections that will form a true white highlight. Spray with graded tones at the lighter end of the tonal scale, balancing these against the shadows sprayed previously **13**. Lift the mask sections inside the rim of the jar, leaving only main highlights masked, and spray with graded tone **14**.

Lift all remaining sections of mask from inside the outline shape of the jar. Check and adjust the balance of tones as necessary **15**. When the image is satisfactory, peel back the masking film from the background of the artwork, revealing the clean outer shape of the image, and lift the strip of masking film covering the highlight on the brush handle **16**.

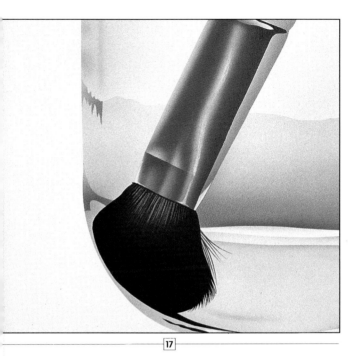

17

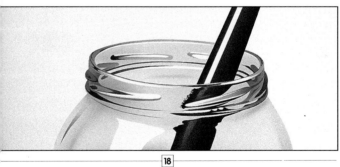

18

Enhance the detail by scratching back loose highlights on the ferrule of the brush and fine linear highlights in the brush bristles. Complement this with fine brushwork to increase the detail of the splayed bristles 17. Scratch highlights into the brush handle and rim of the jar, and use a paintbrush to soften the left-hand edge of the handle 18 to complete the image 19.

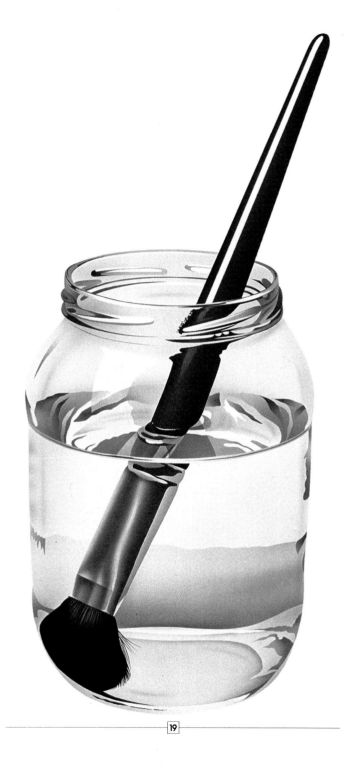

19

GLOSSARY

Acetate A transparent film, produced in a variety of weights and thicknesses, used in airbrush work for loose masking and cut stencils.

Acrylics Paints consisting of pigments dispersed in a binding medium of synthetic acrylic resin, available in liquid or paste form.

Artboard A smooth-surfaced support particularly suitable for airbrushing as the surface allows a high degree of finish to graphic work and illustration. It is available in various thicknesses, flexible or rigid.

Artwork A graphic image or illustration of any kind, which may be intended for reproduction.

Bleed 1 A ragged line of color caused by paint penetrating beneath the edge of a mask. **2** The effect of a color which shows through an overlying layer of opaque paint.

Color cup A type of paint reservoir attached to certain types of airbrush, a metal bowl which is an integral part of the tool.

Compressor An electrically-driven mechanism designed to supply a continuous source of air to an airbrush.

Double-action The mechanism of an airbrush which allows paint and air supplies to be separately manipulated by the airbrush user. In independent double-action air-brushes, paint and air can be fed through in variable proportions, enabling the user to adjust the spray quality.

Film masking See Masking film.

Freehand The technique of airbrushing without use of masks.

Ghosting The method of overlaying layers of spray to render a surface as if it were transparent.

Gouache A type of paint consisting of pigment in a gum binder and including a filler substance that makes the color opaque. It is a viscous substance and must be diluted with water to a fluid consistency for use in airbrushing.

Grain The surface quality of paper or board resulting from the texture of its constituent fibers and the degree of surface finish.

Ground 1 The surface of the support used for airbrush painting, e.g. paper or board. **2** The overall area of a picture or design on which particular images or graphic elements are arranged.

Hard edge The boundary of a shape or area of color in an airbrush image which forms a clean edge between that and the adjacent section of the image. In airbrushing, this effect is produced by hard masking.

Hard masking The use of masks such as masking film or stiff cardboard which lie flush with the surface of the support and create sharp outlines to the masked shapes.

Highlights The lightest areas of an image. With transparent media, highlights may be formed by leaving areas unsprayed to show the white of the support; using opaque color, highlights can be sprayed in white to enhance tonal contrast or create special effects.

Illustration An image accompanying a specific text or depicting a given idea or action; often intended for reproduction in printed works.

Ink A liquid medium for drawing and painting, available in black, white and a range of colors; ink is categorized as a transparent medium.

Internal atomization The process by which medium and air supply are brought together within the nozzle of an airbrush to produce the fine atomized spray of color.

Keyline An outline drawing establishing the area of an image and the structure of its component parts.

Knock back To reduce highlights or other light areas of an image, reducing the overall tonal contrast, by spraying over white areas and pale tones.

Loose masking The use of materials such as paper, cardboard, plastic templates etc. as masks for airbrush work, which do not adhere to the surface of the support

and can be lifted or repositioned according to the effect required. 3-D objects can also be used for particular effects of shape and texture.

Mask Any material or object placed in the path of airbrush spray to prevent the spray from falling on the surface of the support. See Hard masking, Loose masking, Masking film, Soft masking.

Masking film A flexible, self-adhesive transparent plastic film laid over a support to act as a mask. The material adheres to the surface of the support, but the quality of the adhesive allows it to be lifted cleanly without damage to the underlying surface. This is the most precise masking material for airbrush work.

Medium The substance used for creating or coloring an image, e.g. paint or ink. See Acrylics, Gouache, Ink, Watercolor.

Modeling The method of using tone and color to render a two-dimensional image with an impression of three-dimensional solidity.

Needle A component of the airbrush which has the function of carrying the medium from the paint reservoir to the nozzle of the airbrush.

Opaque medium A paint capable of concealing surface marks, such as lines of a drawing or previous layers of paint. This is due to a filler in the paint which makes it tend to dry to a flat, even finish of solid color. See Gouache.

Propellant The mechanism used to supply air to an airbrush. Cans of compressed air are available which can be attached to the airbrush by a valve and airhose, but a compressor is the most efficient means of continuous supply.

Rendering The process of developing a composition from a simple drawing to a highly finished, often illusionistic image.

Reservoir The part of an airbrush which contains the supply of medium to be converted in spray form. In some airbrushes this is a recess in the body of the airbrush, in others a color cup mounted on the airbrush or a jar attached above or below the paint channel.

Scratching back The process of scraping paint from a support with a scalpel or other fine blade to create a highlight area or remove color when an error has been made.

Soft edge The effect of using loose masks or freehand airbrushing to create indefinite outlines and soften the transition between one area of an image and the next.

Soft masking The use of masks held at a distance from the support surface to soften the sprayed area, or a masking material which creates an amorphous effect, such as cotton balls.

Spatter A mottled color effect of uneven spray particles produced by using a specially made spatter cap attachment for the airbrush nozzle, or by using the control button to vary the paint/air ratio within the airbrush.

Spatter cap A nozzle attachment for an airbrush designed to produce an uneven spray effect.

Tone 1 The scale of relative values from light to dark, visually demonstrated in terms of the range from black, through gray, to white, but also applicable to color effects. **2** Any given value of lightness or darkness within a picture or design, or in an individual component of an image.

Translucency The quality of a surface or object which transmits some light, allowing objects or images positioned behind it to be viewed in part or indistinctly.

Transparency The quality of a surface or object which transmits light, so that objects or images positioned behind it are visible through the original object.

Transparent medium A medium such as watercolor or ink which gains color intensity in successive applications but does not conceal underlying marks on the surface of the support.

Vignette 1 A graded tone. **2** An area of graded tone used to frame or focus a central image.

Watercolor A water-soluble paint consisting of finely ground pigment evenly dispersed in a gum binder. It is available in solid and liquid forms; liquid watercolor is the most useful type for airbrushing.

INDEX

CREDITS

p48 John Spires, courtesy of
Artists Inc.;
p49 John Spires, courtesy of
Artists Inc.;

Demonstrations by Mark Taylor
Diagrams by Craig Austen